Sketching Harbours and Boats

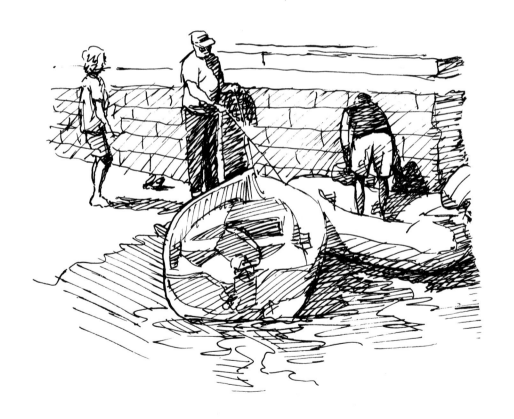

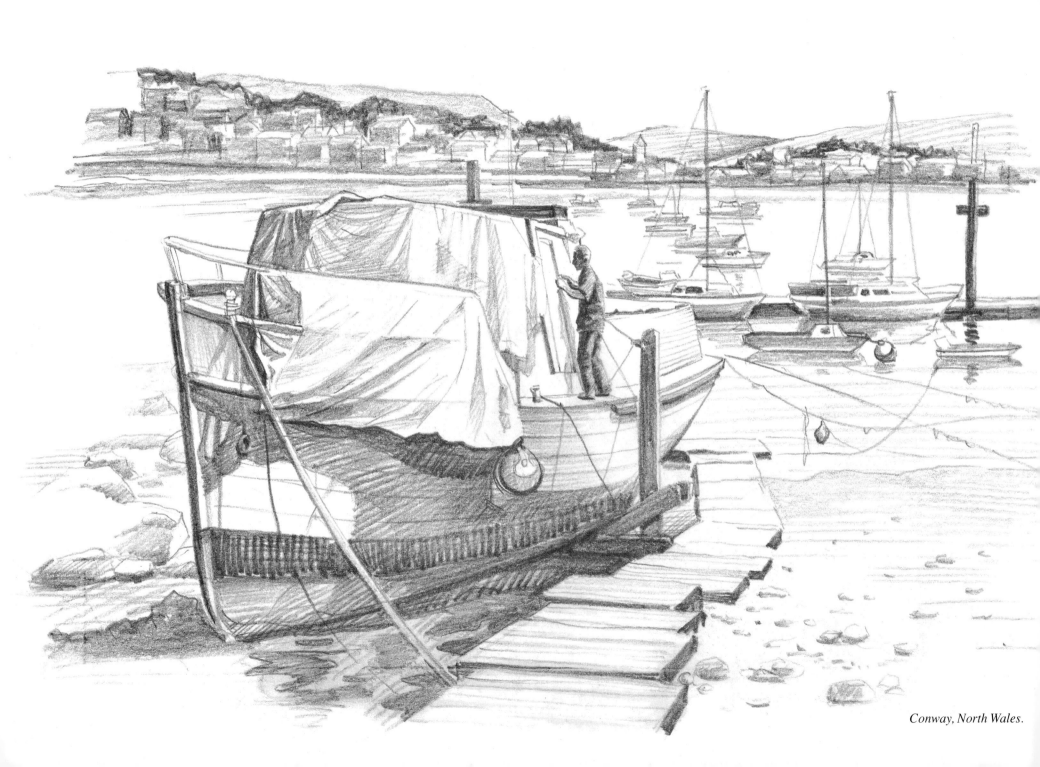

Conway, North Wales.

Sketching Harbours and Boats

ROBERT NORRINGTON

CASSELL

This book is dedicated to my mum for her 40 years of encouragement, her four hours of proof-reading and her never-ending cups of tea.

Cassell
Wellington House, 125 Strand
London WC2R 0BB
www.cassell.co.uk

Distributed in the United States by
Sterling Publishing Co. Inc.
387 Park Avenue South
New York NY 10016-8810

British Library Cataloguing-in-Publication Data
A catalogue record for this book is available from the British Library

ISBN 0-304-35117-2

Printed and bound in Great Britain by
Hillman Printers (Frome) Ltd, Somerset

Contents

Before we start

Introduction

After many years of 'constructing' all kinds of imagery in all kinds of media, from film to murals and exhibitions, I still find tremendous joy in the simple pleasure of getting out and about with a sketchbook and documenting ready-made scenes and details from everyday life.

There is something timeless, and therefore reassuring, about drawing what you see, when and where you see it. Better still, without looking hard for a unique view or a particular event, it is always possible to find things of interest around us in which to become completely absorbed whilst recording our own very personal impressions of them on paper.

This is particularly so where boats and harbours are concerned. I find that the general subject area, perhaps more than most others, offers a multitude of inspirational material – whether you are unravelling a complex array of ropes and pulleys on a racing yacht or simply trying to convey the impression of sunlight accentuating the ripples on the surface of the sea.

In this book I will attempt to lead you gently through some of the ways that you can really begin to enjoy sketching, without suffering too much anxiety and without making some of the more common errors to which beginners are so very often prone.

Having said that, of course, it is inevitable that we will all make mistakes in the drawings we do. You'll probably find quite a few of mine in the pages of this book. The trick really is not to be afraid of making them – I have always believed, in art as in many other things, that the path to success is paved with the errors from which we learn and grow.

In sketching, I have found that it is important to 'engage' with the chosen subject; to develop a way of seeing and understanding its essential form and function, before interpreting all that understanding through your drawing. Ultimately a sketch proves, to yourself, how well you have grasped the essential qualities of what you're looking at. It is also a means of communicating these things to other people – in a way that a photograph can never do.

You may become fascinated, for example, by seeing how a car ferry is loaded or by the plethora of little boats weaving to and fro in a busy harbour. I will try to show you how to get maximum enjoyment and satisfaction from interpreting these things with a sketchbook and pencil.

Robin Brington

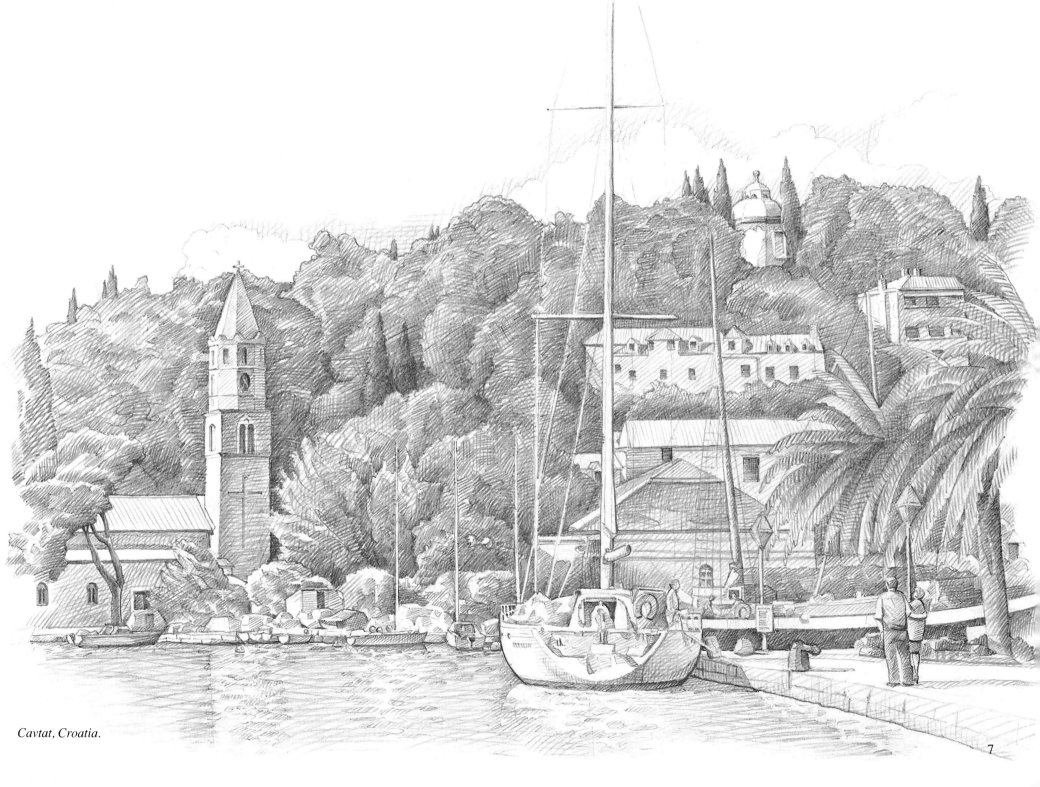

Cavtat, Croatia.

Preparation

Everyone's personal preference in choice of materials and methods will be different. Like many other pursuits, we only discover the way of working that is most comfortable for us by trying different things. In the context of this particular book I felt it was important not to offer too wide a range of options because that can be a little perplexing.

When I was at secondary school I can well remember, despite the cajoling of my enthusiastic art master, how confident I felt with a pencil in my hand and how unconvincing were my efforts in other media – I was particularly terrified of oil paints. In my opinion, graphite pencils are the most versatile and forgiving of all mark-making tools, and probably the most underrated in terms of artistic results.

HB sketch.

For this reason, I have put the emphasis in this book firmly on pencil work whilst suggesting just a few interesting variations and alternatives which I feel offer a natural progression once the basic skills have been mastered.

Choosing pencils

Were you to walk into a local newsagent and ask to buy a pencil, you would undoubtedly be sold an HB, the most common grade which lies about halfway along the scale between soft and hard.

Although they are sometimes useful for lightly sketching in outlines before getting down to the real business of drawing, HBs are really neither fish nor fowl – not hard enough for precise lines and at the same time not soft enough to produce a good tonal range.

As a rough guide, look at the range of marks on the right made by the points of ordinary graphite pencils. See how the point of the very hardest pencil, the 8H, produces a thin, light grey line which barely varies in width or tone, no matter how hard you press down on it.

The 6B, at the other end of the scale, is a more versatile tool, particularly useful for broad tonal areas or gradations from light to dark. Different amounts of pressure on the tip give you varying depths of tone.

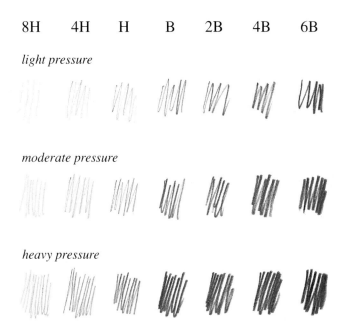

Ultimately you will find your own favourite range of pencils but, if you start with two each of the above range, you will, through practice, get used to the characteristics of each type and find out for yourself which is most suited to the kind of sketching you want to do.

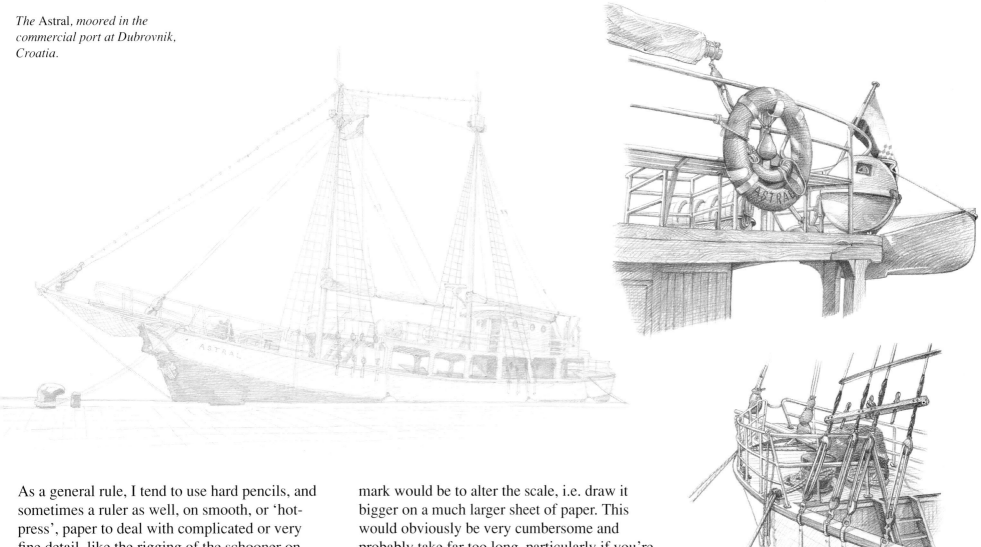

As a general rule, I tend to use hard pencils, and sometimes a ruler as well, on smooth, or 'hot-press', paper to deal with complicated or very fine detail, like the rigging of the schooner on this page. Notice how the harder lead gives a virtually uniform weight of line. Softer pencils at this sort of scale would not give a precise enough line to pick out the detail clearly.

The only other way to convey the whole of a subject like this with a 'blacker' or more varied mark would be to alter the scale, i.e. draw it bigger on a much larger sheet of paper. This would obviously be very cumbersome and probably take far too long, particularly if you're perched on a bollard on the dockside, as I was.

The better alternative, I always find, is to get up close, to concentrate on just a small area of the subject as in these other two drawings, both done with a 4B pencil on smooth heavyweight cartridge paper.

Tonal effects with pencils

To create areas of tone in different shades of grey there are a number of options. Any pencil, sharpened with a blade or a rotary sharpener (I always use a surgical scalpel with inter-changeable, 10A blades), will give a broader and lighter mark when the side of the lead is held almost flat on the paper.

The width and tonal strength of the mark is usually determined by the softness of the lead. The very soft pencils with 'fat' leads can also be carefully fashioned with a sharp blade into a square, or chiselled, end. On the left are some examples of tonal effects achieved with different kinds of leads.

Using the side of the lead, or the chiselled end, of a very soft pencil on a lightly-abraded surface allows you to fill large areas of more or less uniform tone ranging from light grey to almost black. At the same time, using the sharpened point of the same pencil allows you to produce the dark, hard edges required, for instance, to define the jibs of the cranes in the 4B drawing on the right. Four distinct tonal areas are here achieved with varying pressures on the side of the same lead.

Hatching and crosshatching are ways of building flat or graduated areas of tone. With hatching, all the strokes go in the same direction; with crosshatching, they go in different directions and are overlaid – one hatched area on top of another. These two techniques have the advantage of blending with the outlines of objects and are particularly suitable when you need to keep the key, or overall tone, of the drawing light and open.

H

2B

6B

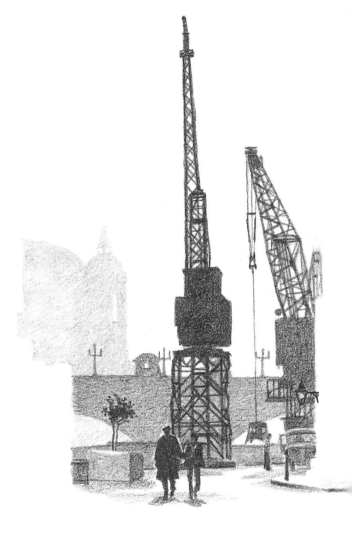

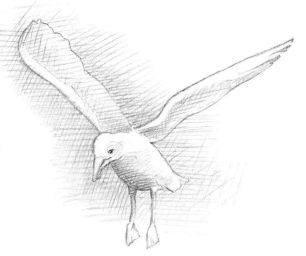

Choice of paper

Unlike media such as oil paints or watercolours, you can by and large draw with pencil on almost any surface. There are, however, some papers which are designed to receive pencil more sympathetically than others.

In order not to complicate matters I tend to see it as a straightforward choice between three simple options:

The sketches above and to the right show the application of different methods of hatching. The seagull hovering on an updraft was done with an H pencil and the aft-deck of the racing yacht was drawn with a 4B pencil.

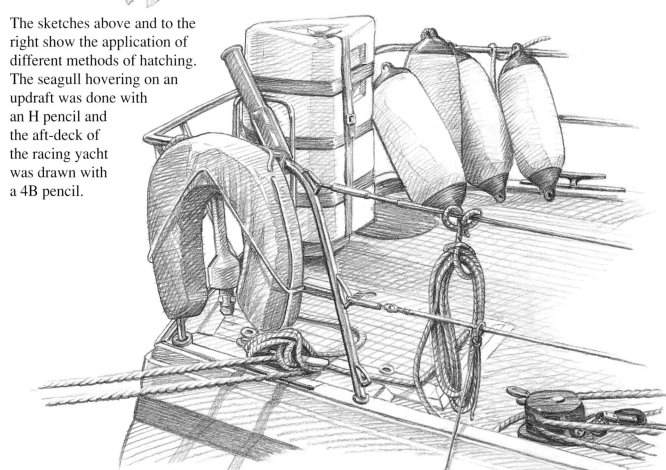

- Smooth cartridge or hot-press paper of varying weights for general purpose sketching and for detailed work. You can use almost any kind of media on this surface, with the notable exception of oil-based paints. It is advisable, however, that you use a heavier weight, say 220gsm, if you want to apply a wash to your drawing – otherwise it will tend to stretch and 'cockle'. A3 or A4 size pads are widely available.

- Lightly-abraded, more absorbent surfaces, such as Not or CS2, for looser more textured results, including line and wash or the use of water-soluble pencils. This can be virtually any weight as the surface is designed to be very versatile and won't distort. Colour-tinted surfaces, such as Canson paper, are also quite popular, particularly for charcoal, crayon or pastel work.

- Pre-stretched watercolour papers for acrylics, gouache or watercolours. My personal favourite is called Arches, but it is rather expensive and doesn't come in pads. There are two or three well-known and perfectly good brands that are reasonably priced and widely available in pads of various sizes.

Of course you do not have to stick to these guidelines and, no doubt, as you progress you will, through experimentation, find papers and boards which more particularly suit your technique.

On this page and the opposite one are some examples of the effects that you can achieve drawing on these different types of paper in various media.

Other essentials

I have already mentioned the use of a surgical scalpel for sharpening pencils. A packet of emery boards or a small grindstone, made from fine sandpaper wrapped around a block of wood, are useful additions to the sketcher's armoury as they will help to keep your pencil points needle-sharp without you having continually to shave lumps off the wooden shaft.

Some artists prefer to use 'clutch pencils' with self-propelling and interchangeable leads. Personally, as I am generally quite heavy-handed, I find the leads in these more inclined to break than in the conventional type of pencil. Most of the people I know who use them are architects or industrial designers, using 2H or 3H leads for the light, precise lines required in measured drawings.

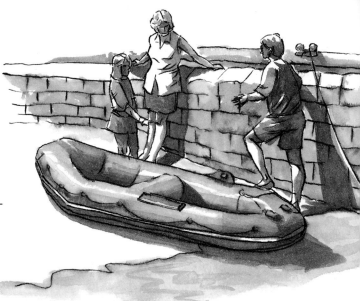

Line and wash sketch on CS2 paper – a family inflating their dinghy at Salcombe, Devon.

There is a great deal of good sense and no shame in using an eraser to get rid of unwanted marks. There are two types which I use regularly. The first is a soft putty rubber which will gently expunge almost any pencil mark from any kind of surface, by transferring it onto the rubber. Pressing hard won't damage the paper surface but the eraser itself tends to get very dirty.

The other type is the much harder and more conventional type of pencil rubber. Whilst these are generally more effective in getting rid of errors on even the softest papers, they can damage the drawing surface if you rub too hard. I generally use a hard rubber only on very hard surfaces such as line boards or canvas.

2B pencil on smooth cartridge paper – a ten-minute sketch of the Old City port, Dubrovnik, Croatia.

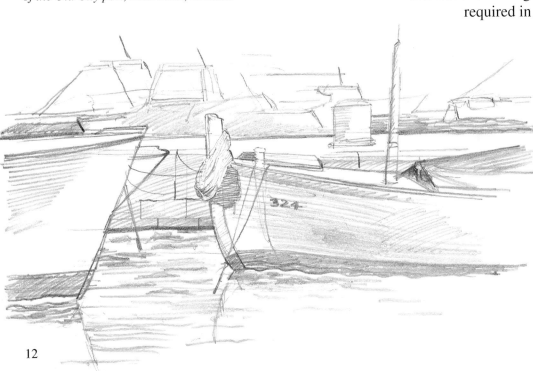

A short ruler may come in handy, especially if you lack confidence with drawing straight, or 'straightish', lines freehand. Again, there is no shame whatsoever in using any mechanical aid that helps you to achieve the desired result.

If you intend to work with a ready-made proprietary pad of paper with a stiff card backing there is probably no need for a drawing board as well. However, it is occasionally difficult to hold steady the paper you're working on, particularly in a gusting wind, so a not-too-bendy piece of plywood or hardboard, no larger than A2 and not too thick (so it remains easy to carry), should do the trick.

Four large stainless steel drawing board clips from the art shop should be enough to secure the paper or pad onto the board unless you're planning to go sketching in a hurricane. On the subject of inclement weather, it's a good idea always to carry a large polythene or waterproof bag to protect your work and materials just in case you get caught out in the rain.

The final item I feel it worth mentioning in the sketcher's equipment list is a comfortable folding stool, preferably one with built-in pockets for all the other equipment you need. One of these need not be very costly and it will save having to carry a separate bag for your materials.

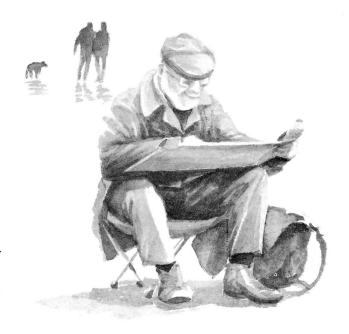

Gouache on Arches rough paper – Bill Hoskins on Chapel Porth beach, Cornwall.

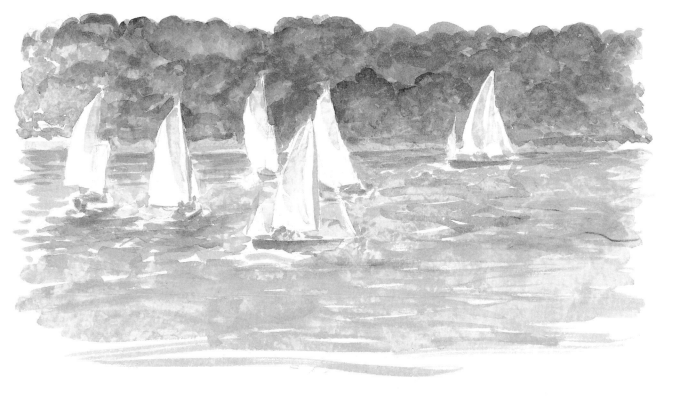

Although I do own an artists' stool, I often leave it behind when I go sketching and, equally often, regret having done so as I find myself sitting for an hour or so on a patch of wet grass or a knobbly bit of concrete.

Watercolour sketch on Watman paper – yacht race at Salcombe, Devon.

13

Building confidence

In order to prepare yourself for a sketching session it is a good idea, especially if you are just beginning, to try a few simple drawing exercises. They will help you to get the feel of the process and to ensure that you feel comfortable with the materials you have chosen.

Assuming you are armed with a relatively soft pencil and a pad of smooth cartridge paper, try lightly running the point of the pencil horizontally across the sheet about 3 cm down from the top and from left to right, or right to left if you're left-handed. The line will never be completely straight, regardless of whether you are an accomplished artist, but you will find that by resting the heel of your hand gently on the paper's surface, you will have more control.

Now try drawing a vertical line about 3 cm in from the edge of the page. By hooking your little finger loosely onto the side of the pad and keeping it stiff as you move your hand downwards, the line will run parallel to the edge and be fairly straight. Try these two exercises a number of times with different grades of lead.

Next, look at the sketch on the left-hand side of page 8 and try to copy the different strengths of tone. Choose a pencil of equivalent softness to one of the three areas and get used to feeling the varying pressures and angles of the lead required to make these kind of marks.

The final exercise is called the *Drawing Race*. Take one sheet of paper only and, using the initial letter of your first name, try to draw ten objects which begin with the same letter within just five minutes.

If you've ever played *Pictionary*, you'll be familiar with the idea. The trick is to find the visual essence of the object and draw it as if you're trying to make yourself understood to someone who doesn't speak English. On the right is my attempt to represent ten objects beginning with the letter 'r'.

Having done these exercises you should feel a little better equipped to tackle that most terrifying of all things to an artist – the blank sheet of paper.

Choosing a subject

There is an old mnemonic in the world of advertising represented by the initials KISS. These stand for 'Keep It Simple, Stupid', a marvellous piece of advice for those starting sketching.

Given the enormous and diverse choice of interesting subjects available in, for example, a busy fishing port, it is always a great temptation to try and fill your picture with as much detailed information as possible.

A good way of avoiding the pitfalls of over-ambition when beginning is deliberately to select a small and well-defined group of objects that are not too far away from you. Try to find a line of vision which excludes a distant horizon and does not incorporate tall buildings, people or complex things.

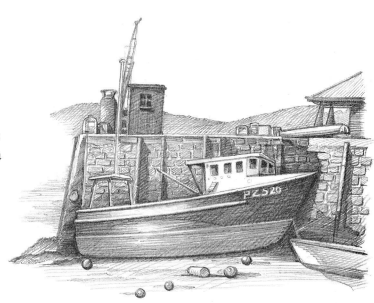

Low tide at Barmouth, Gwynedd, Wales.

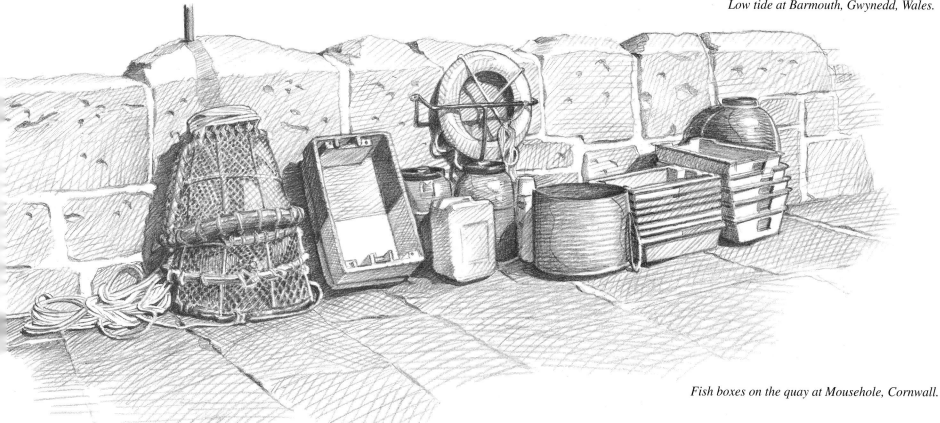

Fish boxes on the quay at Mousehole, Cornwall.

15

A few basic rules

Setting up

Finding the right spot to settle down for an hour or two is equally as important as choosing the right subjects.

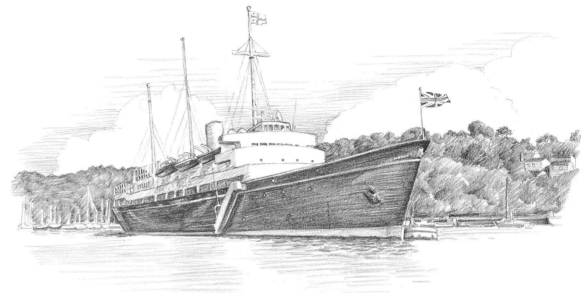

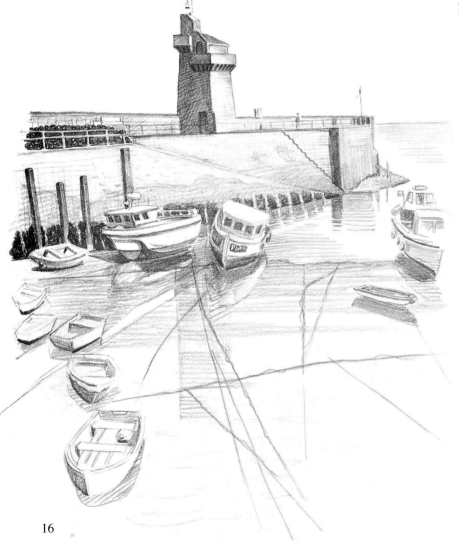

Always try to ensure that what you are drawing is not going to change significantly before you've finished. It would be very frustrating to find that the boat which is the focal point of the intended picture suddenly weighs anchor and departs before your eyes.

Other conditions can also change, sometimes so imperceptibly that you hardly notice until something in your composition starts to look wrong. The movement of the tide is a good example of this.

In *Low tide at Lynmouth* (Devon) on the left, it was important that I completed the sketch during the period of slack water.

The *Royal Yacht Britannia*, above, moored at Dartmouth, Devon, obviously wasn't going anywhere in a hurry. It was a bright day and the clouds were few and low.

It is of course not always possible to predict changes in the weather particularly in the UK. Shadows and reflections can disappear in an instant so, if you intend to make a feature of these, it is best to choose a sunny day with little cloud.

Above all, try to make sure that you're going to be as physically comfortable as possible for as long as it takes to complete your drawing.

Basic composition

Image placement

Every artist, including myself, has had the experience of trying to draw a scene by starting in the top left-hand corner and running out of paper before getting everything in.

The best way to avoid this is to decide, before you start, on the approximate extent and layout of the drawing, as well as the scale and area of paper it is going to occupy.

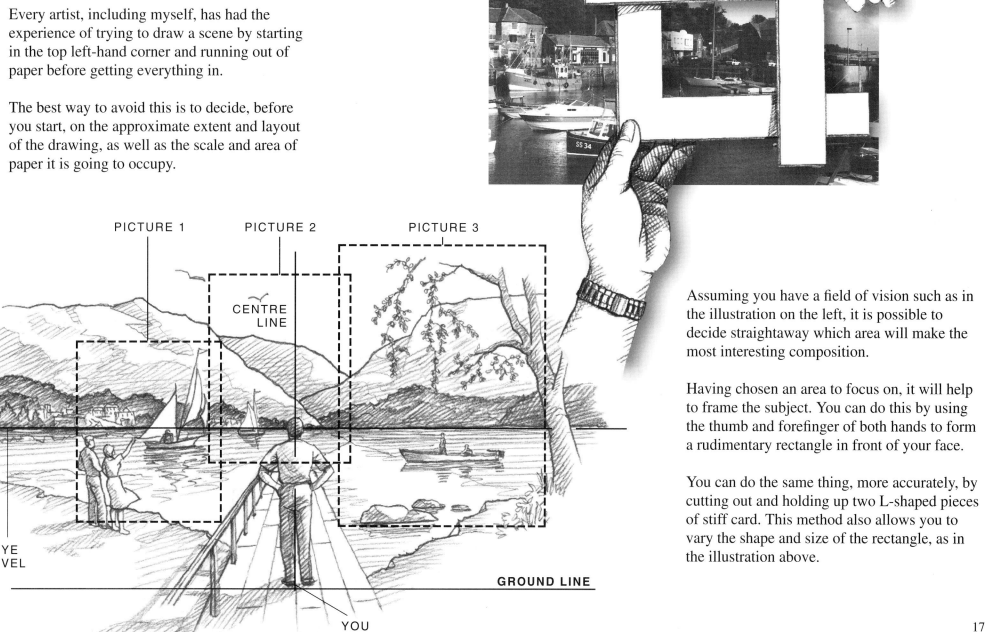

PICTURE 1 PICTURE 2 PICTURE 3

CENTRE
LINE

YE
VEL

GROUND LINE

YOU

Assuming you have a field of vision such as in the illustration on the left, it is possible to decide straightaway which area will make the most interesting composition.

Having chosen an area to focus on, it will help to frame the subject. You can do this by using the thumb and forefinger of both hands to form a rudimentary rectangle in front of your face.

You can do the same thing, more accurately, by cutting out and holding up two L-shaped pieces of stiff card. This method also allows you to vary the shape and size of the rectangle, as in the illustration above.

Balancing the composition

In order to make quite sure I get the most from the scene in terms of the composition, I like to make a series of rapid 'thumbnail' sketches.

It really is worth spending five minutes roughing in the main features of the picture. This not only clarifies the general layout and balance of the drawing, but it also helps to identify the focal points as well as the stronger areas of tone and contrast.

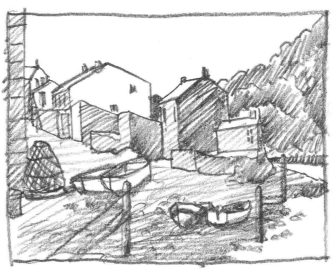

Hope Cove, Devon.

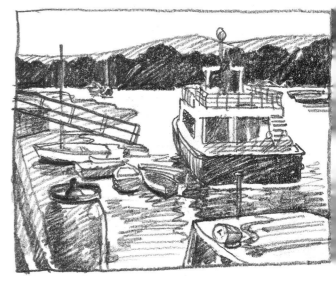

Kingsbridge, Devon.

With each composition I have tried to create a careful balance between a strong feature in the foreground, an interesting middle ground and a well-defined horizon.

Scribbling in the main areas of tone, keeping them to just three gradations – light grey, mid-grey and black – helps to determine whether the composition is going to work. Too large an area of white or black in the wrong place will unbalance the picture.

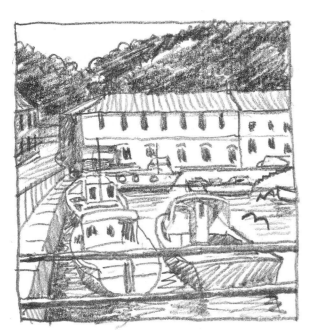

Falmouth, Cornwall.

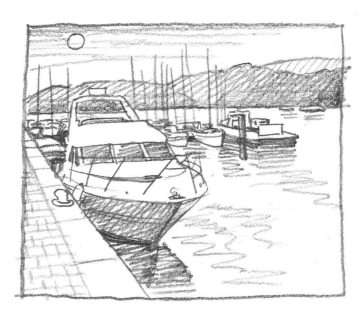

Dartmouth, Devon.

Features and focal points

Because of the wealth of strong visual material in most harbours, it is not always easy to be selective in what you draw.

If you are a recent convert to the joys of sketching, some subjects may prove rather too complex or detailed to tackle, even if you're prepared to spend all day on one drawing – which I wouldn't recommend.

Allow yourself two hours at most for one sketch and, having worked out the framing, decide how much of the total area will be occupied by the main feature. This could be a single boat, a small group of little boats or a shore-based feature such as a lighthouse.

The angle at which you view the main feature will, to a great extent, determine what occupies the rest of the picture area.

This fishing boat was viewed from the promenade above the harbour at Newquay in Cornwall. Because any distant features, like the horizon, were excluded, the composition was uncomplicated.

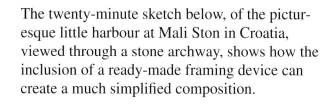

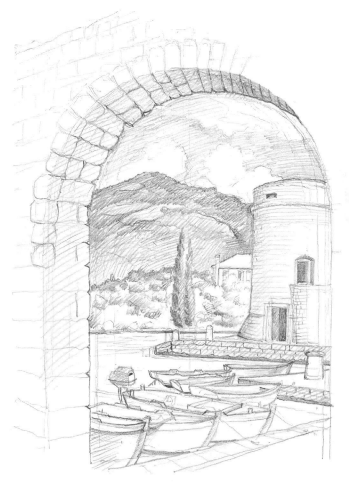

The twenty-minute sketch below, of the picturesque little harbour at Mali Ston in Croatia, viewed through a stone archway, shows how the inclusion of a ready-made framing device can create a much simplified composition.

This also obviated the need for any thought about the limits of the picture area. I only had to decide how close I would sit to the arch.

Decision time

What to put in and what to leave out

The framing exercises and thumbnail sketches will have helped you to decide what's important in the overall composition. It is entirely up to you to determine exactly what you include.

Just because an object appears within your frame doesn't mean you are obliged to show it in the drawing.

You should find that if you allocate about half of your time to the main feature(s) and/or foreground, then you will have to be fairly selective about how much detail you have time to put into the middle and far distance.

Both images on this page were sufficiently interesting in themselves that, working on the old design principle of less is more, I felt it unnecessary to add anything else.

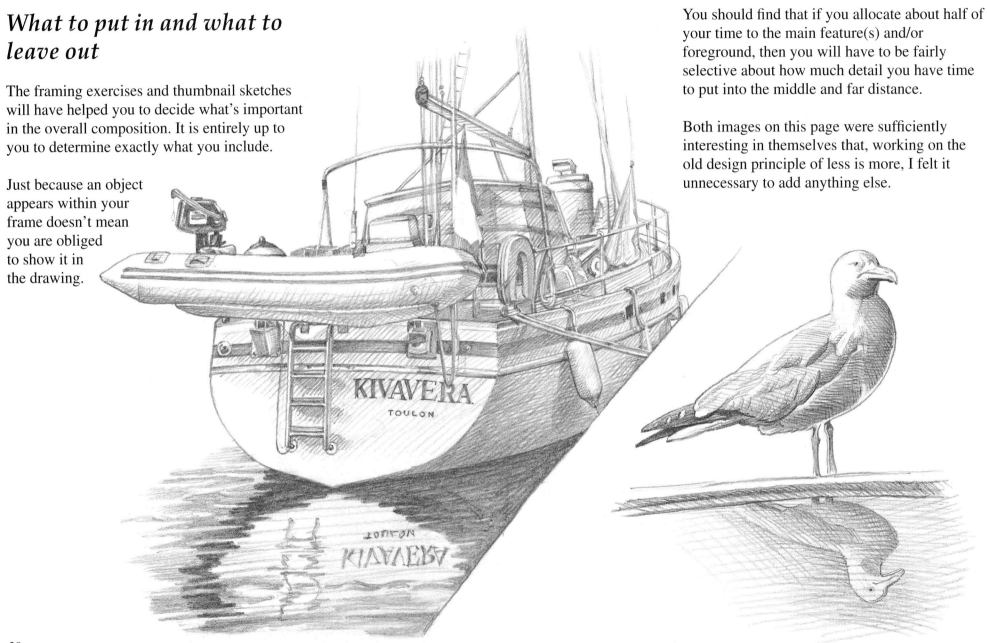

KIVAVERA

TOULON

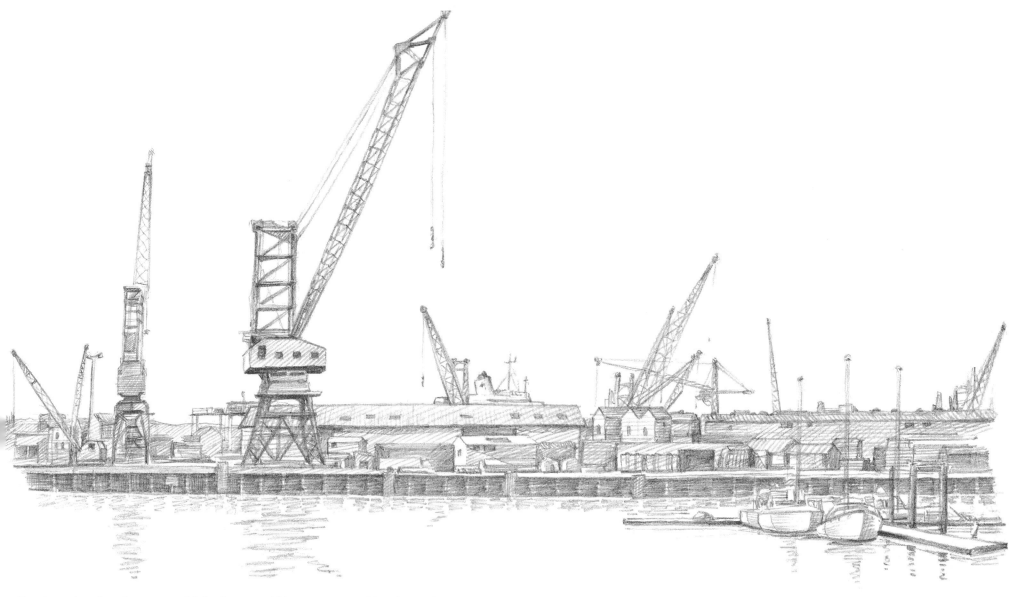

On the other hand, you could find yourself in a situation where there is no discernible foreground feature.

This view of the commercial dock at Falmouth, Cornwall, seen from the fishing port, is to all intents and purposes a flat panorama. I have tried to place more emphasis upon the large crane on the left of the picture in order to give the composition more of a focal point.

Normally, with a subject like this, I would have ignored the sailing boats moored at the small jetty on the right but in this case I felt that the sketch desperately needed something in the middle distance to create depth.

What you see and what you know

Sketching is based primarily upon observation. However, memory and understanding also play a part in helping to decide how we represent what we see.

The more we take note of our surroundings, the better equipped we are to deal with new visual experiences.

Nonetheless, it is often the case that the way things look superficially does not tell the whole story of how they are constructed or how they actually work.

The gargoyle on the right is a good example of this. I discovered its real purpose by happy accident. I had walked past the baroque church of St Blaise in Dubrovnik, Croatia, many times without really noticing these grotesque stone heads which appeared every three metres or so at about eye level.

It was not until I was caught in a sudden, torrential rainstorm that I realized they had a purpose. They were outlets for the surface water from the roof which gushed down the side of the building through concealed conduits.

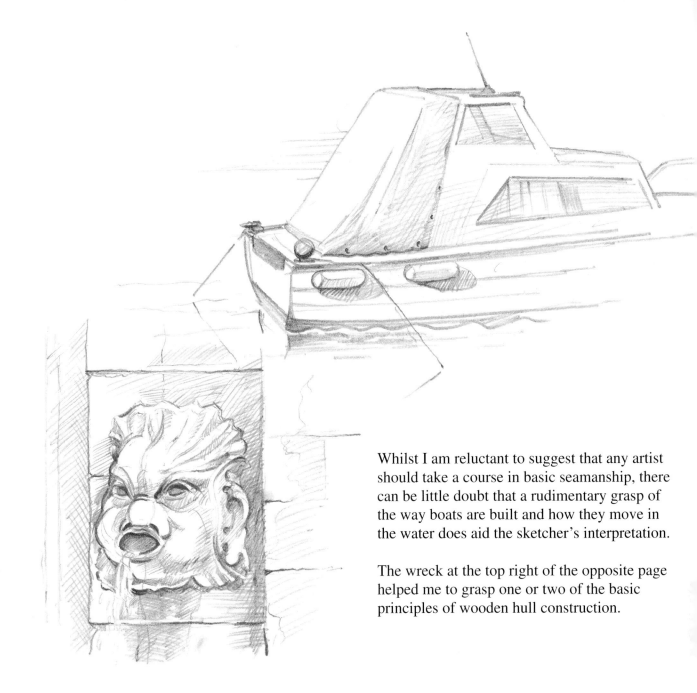

Whilst I am reluctant to suggest that any artist should take a course in basic seamanship, there can be little doubt that a rudimentary grasp of the way boats are built and how they move in the water does aid the sketcher's interpretation.

The wreck at the top right of the opposite page helped me to grasp one or two of the basic principles of wooden hull construction.

Gathering reference

One of the more practical applications of sketching is to glean visual information for more detailed drawings or for developing initial ideas into fully-fledged works of art.

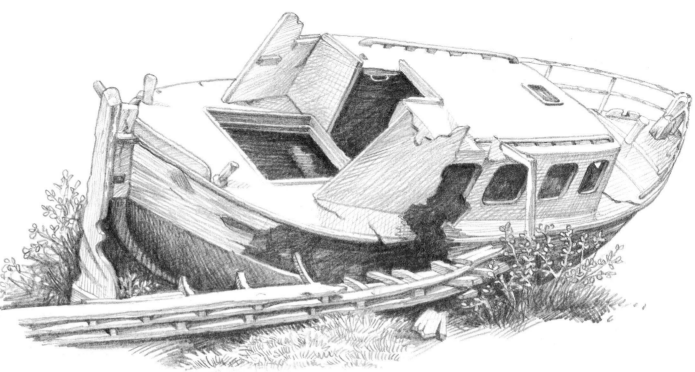

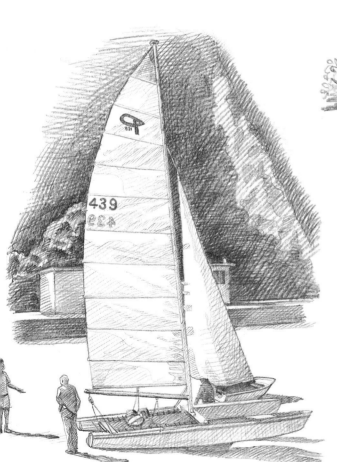

By analysing and noting the form of a yacht, the structure of a sea-wall or the wingbeats of a gull with a few simple lines, we create a valuable record, particularly in circumstances where there is probably only one opportunity in a lifetime to witness a particular scene or a unique event.

It is also a useful habit always to carry a camera so that you can capture the fleeting movements which can sometimes bring a picture to life.

The drawing on the left could not have been completed without resorting to photography to record the two people who suddenly appeared and began to have a conversation while I was sketching their catamaran.

Photographs can also be used to record light conditions and colours which may alter if the weather changes before you've finished the drawing.

Analysing the scene

Sightlines and horizons

Trying to find a simple relationship between foreground, middle ground and distance is not always easy.

One solution that I have found very useful in this respect is to establish a framework with a reasonable amount of sky or water occupying the top or bottom of the picture.

In many cases you will find, as in the sketch of Whitby harbour on the right, that you can employ both features to create a comfortable balance. In this case, the only feature in the foreground is the seagull.

From a high position, sitting on a hilltop or with a clear view out to sea for example, your eye level will coincide precisely with the horizon that you can see.

More often than not the limit of your sight, or 'false horizon', will be defined by rooftops or the hills behind them.

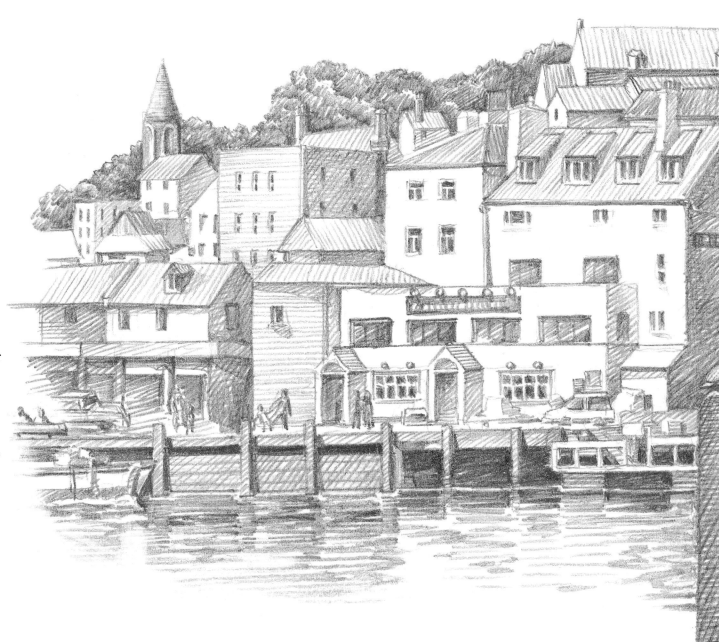

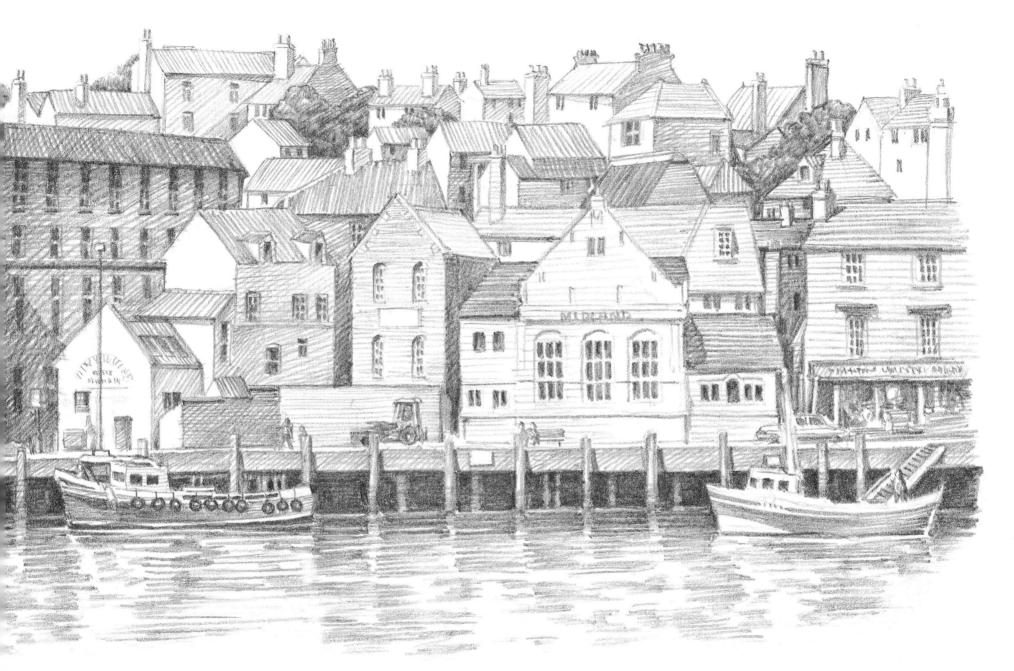

Whitby, North Yorkshire.

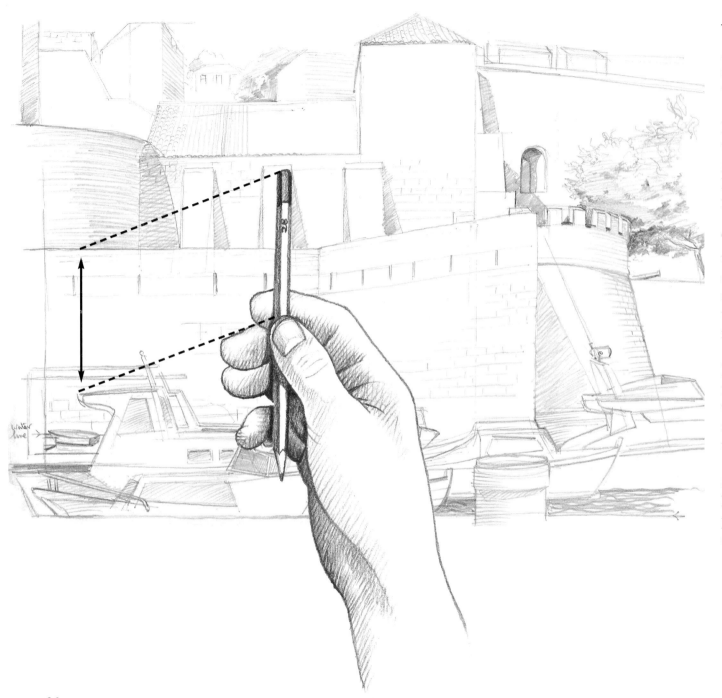

Judging size and distance

Any artist will tell you that the most significant skill you can develop is the ability to evaluate the relative scale of what you see.

Fortunately nature has endowed most of us with the capacity to judge distance fairly well at a glance. What is more difficult is to work out how big everything is according to its distance from your eye.

The tried and trusted, and quite literal, rule of thumb method of visual measurement for sketching purposes is to hold your pencil, as shown on the left, at arm's length and to place the tip of your thumb against it as if you were reading off units on a scale.

If you notice, for example, that a building in the foreground is roughly as high as the length of the pencil and a building in the middle distance is half the pencil's length then you can transpose these ratios to your sketch.

Similarly the pencil gauge can help you to judge horizontal distances as well as angles – particularly useful when calculating the height and angle of a ship's mast and rigging.

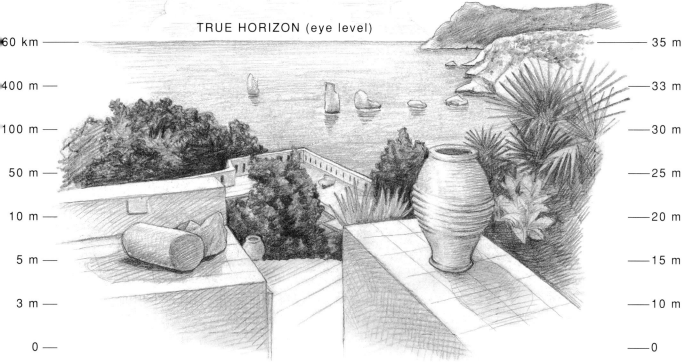

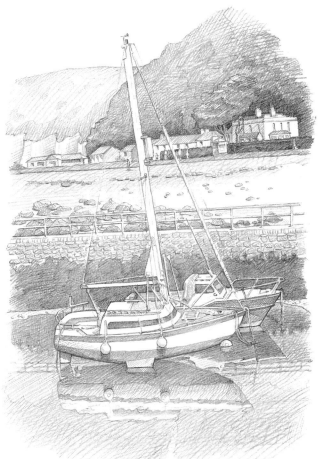

Here is a useful little exercise in judging size and distance. Try marking off a series of equal units down each side of your picture. Then add, in metres, the heights and distances which you think are roughly equivalent to the position of the main features in your composition.

The drawing above, for which I was looking down from a clifftop villa in Ibiza, gave me a fairly good indication of distance because I had a clear view of the horizon. The real problem, however, was to overcome the illusion which makes objects appear closer than they would be if everything were laid out in front of you on the same flat plane, like men on a chessboard.

Looking at the sketch on the right you can see how much more difficult it is to judge distances. At the same time, because everything is based just above or just below the eye level, it is a lot easier to work out relative heights.

Lynmouth, Devon.

Simple perspective

There is no great scientific mystery about working out the perspective of any vista provided you follow a few easy rules.

For the purposes of this book we will stick to the two basic methods – *single* and *two point perspective*.

Single point

On the right is a drawing based upon one vanishing point only. The vanishing point will always appear on your eye level which, in this case, represents the centre of your vision and coincides precisely with the visible true horizon.

Having established the position of the vanishing point it may help to sketch in lightly a number of diagonal lines along which to locate all the vital features of your composition.

Two point

The diagram on the opposite page is similar but, instead of one, there are two vanishing points beyond the left and right limits of the area of vision. These are located, once again, on your eye level but instead of using the centre line to calculate where they meet the eye level, you'll need to find clues within your area of vision.

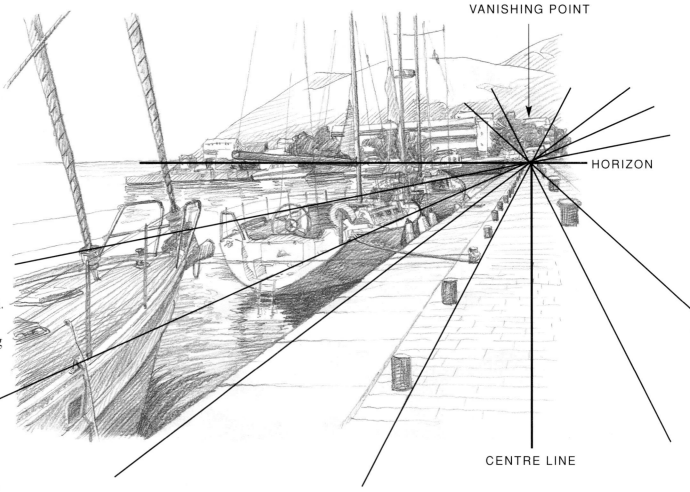

VANISHING POINT

HORIZON

CENTRE LINE

In this scene, the two important clues are the angle of the quayside in the bottom left corner and the waterline at the base of the further harbour wall which, in reality, is situated at right angles to the nearer quayside. These are the 'key angles'.

Having established the two vanishing points, the good news is that by projecting any diagonal from one or both, all your ground lines (e.g. for helping to gauge the relative heights of figures at different distances), as well as the roofline angles should be spot on.

There are, of course, more complex ways of calculating the more difficult issues of pictorial perspective but, if you concentrate to start with on the two more basic ones as illustrated here, you shouldn't go far wrong.

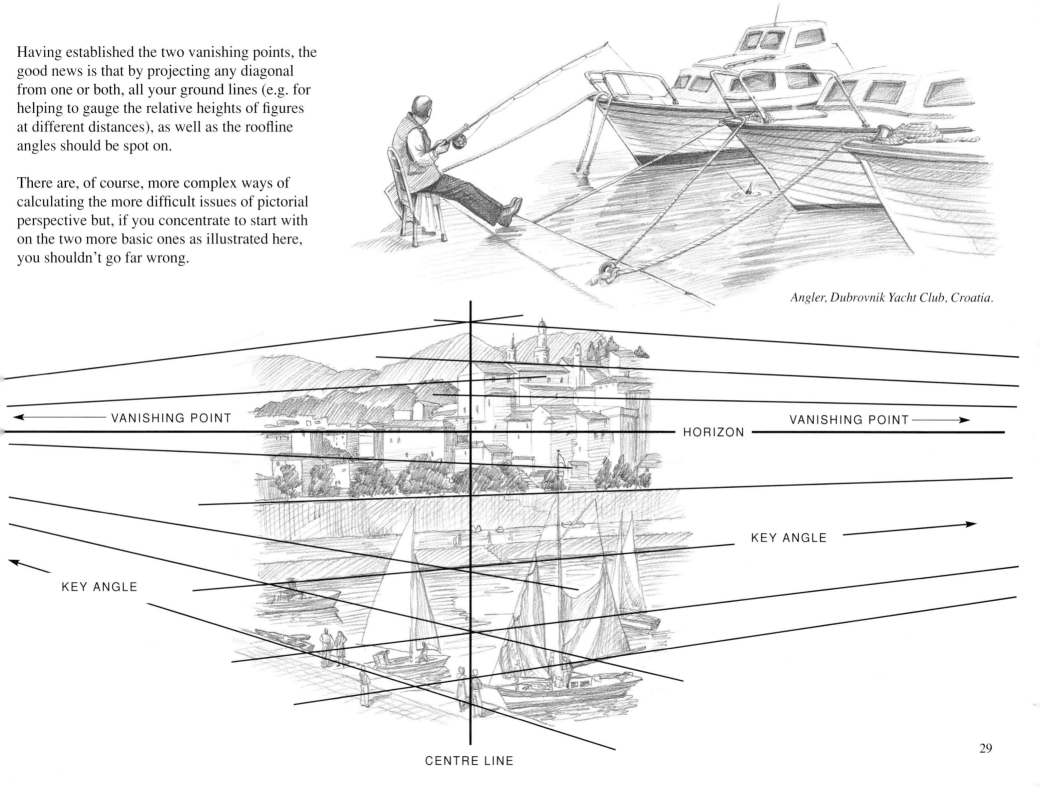

Angler, Dubrovnik Yacht Club, Croatia.

←——— VANISHING POINT

VANISHING POINT ———→

HORIZON

KEY ANGLE ———→

KEY ANGLE

CENTRE LINE

Understanding light

Creating form

At the risk of stating the obvious, the reason we find it difficult to see anything properly in the dark is simply that, without light, form does not exist as a visual entity.

Conversely when we try to copy the formal aspects of an object onto paper it is that effect of light which ultimately creates the most convincing impression.

In order to incorporate a recognition of how the light is affecting the subject in your drawing it helps to work out first where it is coming from.

The easiest way to understand the idea of this is to think about how only one side of the earth has daylight at any one time – when it is light in the northern hemisphere it is dark in the southern hemisphere because it is on the opposite side of the earth and facing away from the light source, the sun.

Similarly, a drawing of any basic form will begin to appear visually more three dimensional if, having determined the direction of the main source of light, we add the tonal effects that represent light and shade.

It is well worth practising this exercise using only the most basic of geometric models before attempting to apply this theory to more complicated shapes. Start with a standard cube or box shape.

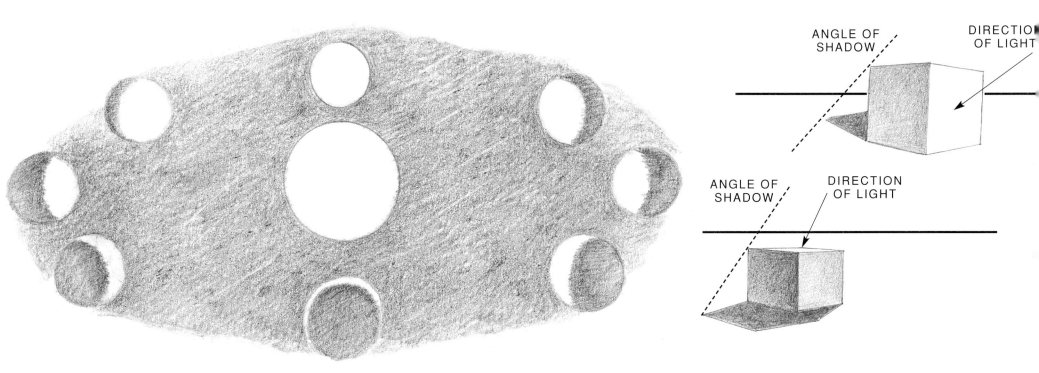

ANGLE OF SHADOW

DIRECTION OF LIGHT

ANGLE OF SHADOW

DIRECTION OF LIGHT

Now try reproducing the effects of direct light on a series of spheres and cones in different positions relative to light sources of differing strengths and directions.

When you feel confident enough you could try tackling more complicated forms.

Even though it constituted only a small part of the intended picture, this ornate, nineteenth-century, iron lamp-post on the quayside at Dubrovnik, Croatia, kept me occupied for nearly an hour.

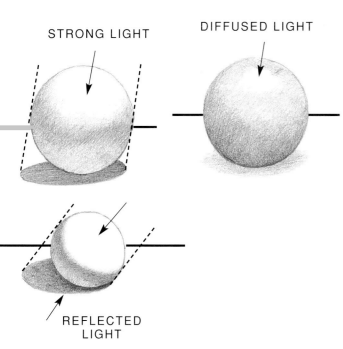

STRONG LIGHT

DIFFUSED LIGHT

REFLECTED LIGHT

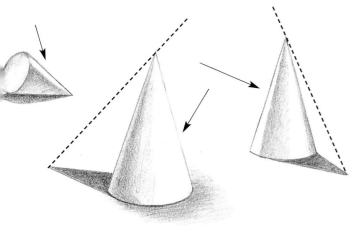

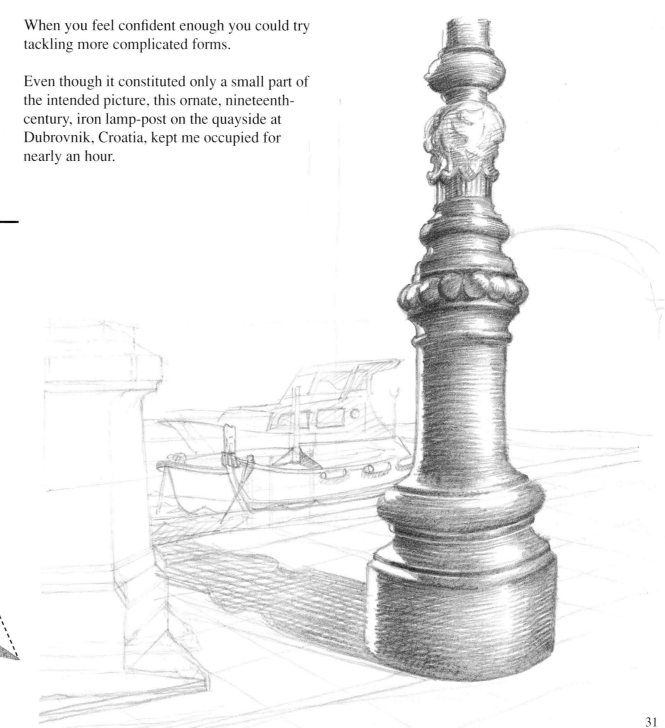

Definition

Although enhancing the appearance of form will help considerably in conveying the impression of reality, it is also desirable if you can find ways of differentiating clearly where one shape ends and the adjacent area begins.

The way we see things naturally is really the greatest ally in this process but occasionally nature needs a little artistic licence in the interpretation.

A good, strong line around the focus of your composition will help it to stand out against the background, as will a generous helping of white space around an object.

Salcombe, Devon.

There really is no substitute for making a few quick thumbnail sketches to determine how dark and light areas are going to work together and where lines or shadows need strengthening to make an item stand out from its surroundings.

Generally speaking, the brighter the light you are working in, the easier it is to create dramatic contrasts within your picture.

Dubrovnik, Croatia.

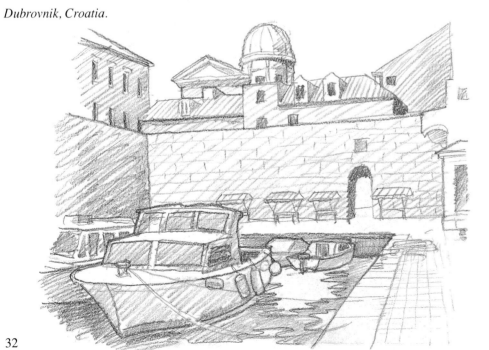

Falmouth, Cornwall.

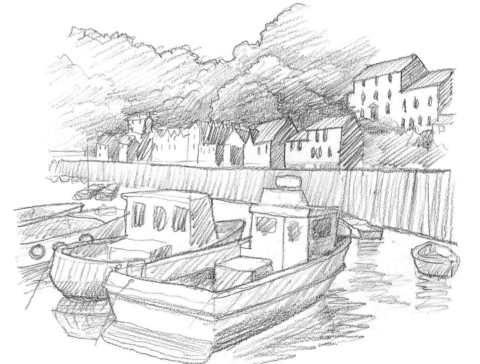

Contrasts are always more marked when things are close to our eye. In order to give sketches more depth and sense of space an artist will often overemphasize the lack of detail and definition in distant features.

In this sketch of two boys sitting on railings at Dartmouth in Devon I have tried to convey a sense of distance by accentuating the contrasting tones in the railings as well as drawing a dark outline with a soft pencil around the figures themselves.

Conversely, for the houses and trees on the other side of the river, I've used a harder pencil to reduce the amount of contrast and give a more monotonal impression.

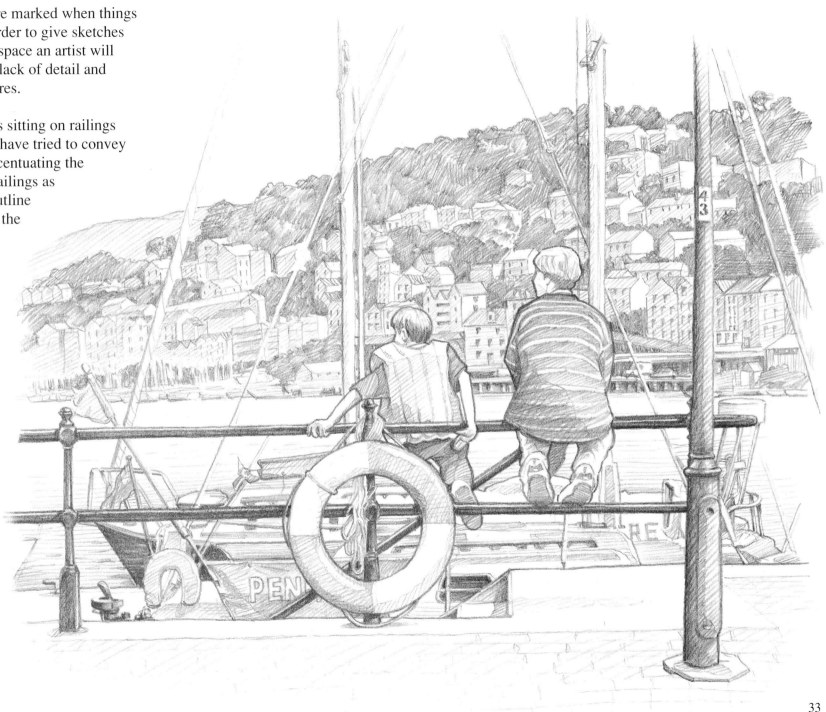

Shadows and reflections

The ambient softness of outdoor light in northern Europe means that a few of the sketches in this book can easily illustrate the above points.

I was lucky enough, however, to be able to sketch this boy repairing his fibreglass dinghy at Salcombe, Devon, on a particularly sunny day.

Of all the problems involved in drawing, this is the area which seems to cause the most puzzlement and frustration.

The earlier section on creating form should help a little with the angles of shadows. Working out the direction from which light is hitting the subject is always half the battle.

Beyond this, a good general rule is: the brighter a single light source is in relation to its surroundings the sharper will be the edge of the actual shadow of the objects.

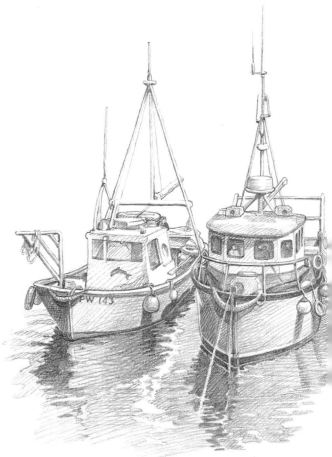

Unless you favour sketching at night, then the chances are that the biggest determining factor will be the strength and position of the sun. At dawn and dusk the shadows cast by objects will always be much longer than at noon when the sun is directly overhead.

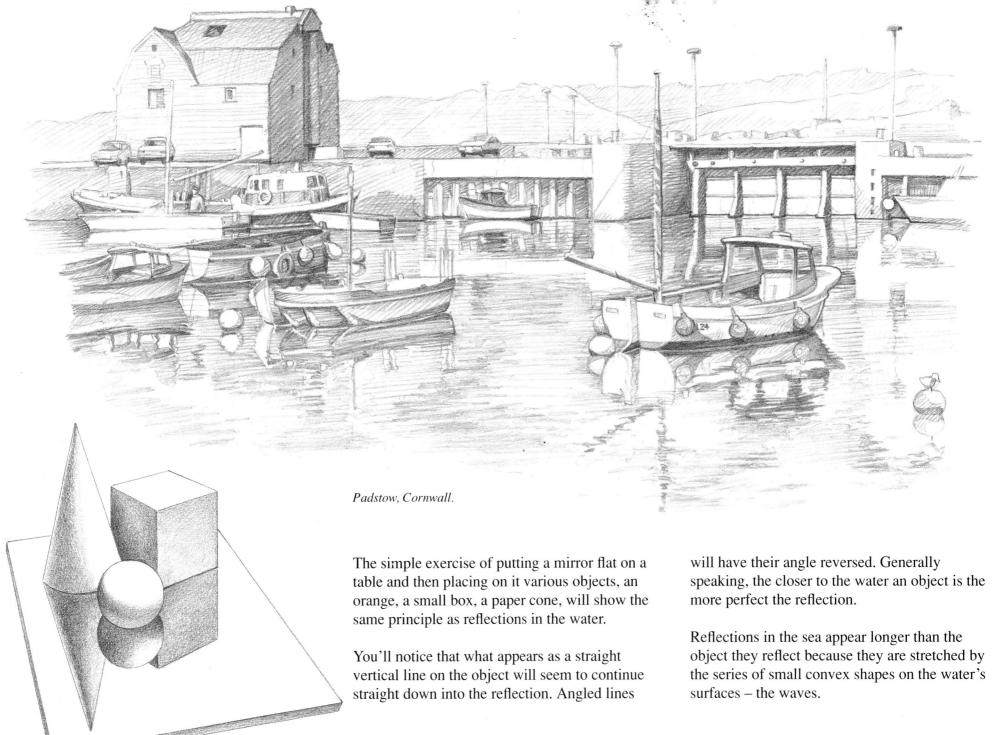

Padstow, Cornwall.

The simple exercise of putting a mirror flat on a table and then placing on it various objects, an orange, a small box, a paper cone, will show the same principle as reflections in the water.

You'll notice that what appears as a straight vertical line on the object will seem to continue straight down into the reflection. Angled lines will have their angle reversed. Generally speaking, the closer to the water an object is the more perfect the reflection.

Reflections in the sea appear longer than the object they reflect because they are stretched by the series of small convex shapes on the water's surfaces – the waves.

35

Bringing drawings to life

Adding figures

The simplest way to create interest in a composition is to include some animate feature – human activity is the most obvious example, but birds, dogs, cats and horses will do almost as well.

The big problem, of course, is that, except in rare cases, people are not going to maintain the same position for the amount of time that it takes to do any more than rough in their outline and main features.

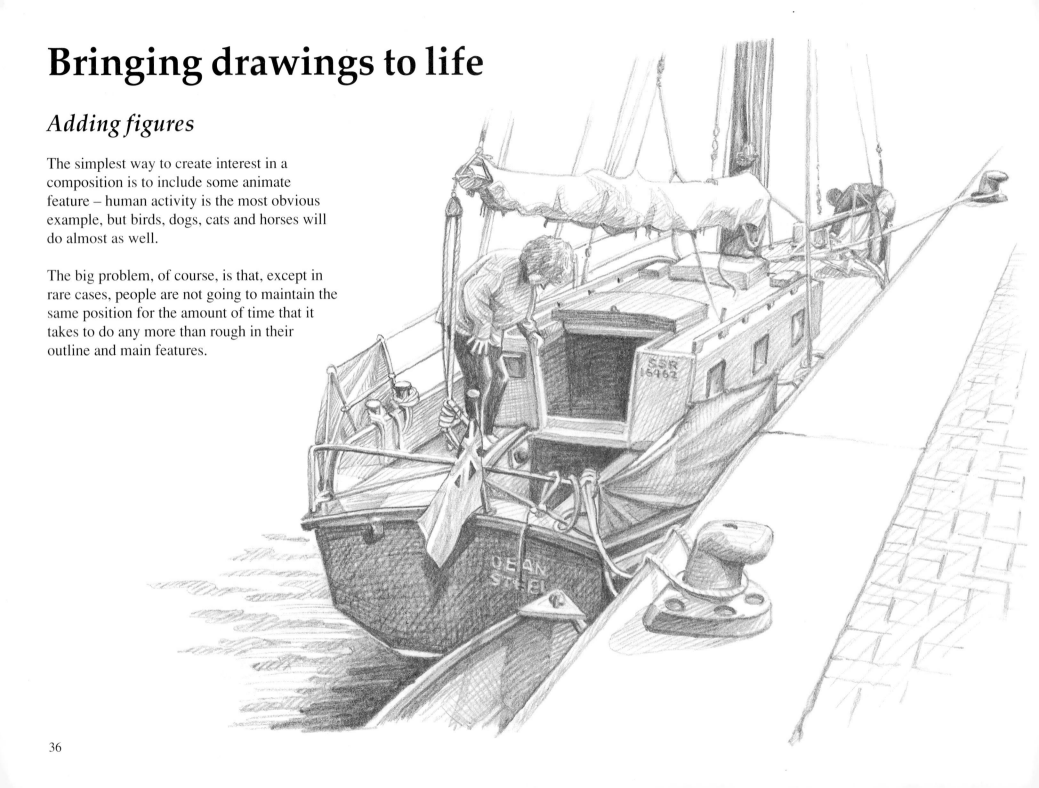

If a detailed and accurate drawing is your ultimate aim, then the camera will capture the detail to be added later whilst leaving you free to concentrate on the rest of the image.

Whenever I get the chance I like to draw the more unusual activities of people and animals. Those involved with boats and water tend to present a good number of such opportunities. My favourite moment over the past year of sketching was when I was lucky enough to spot this gull catching a large eel.

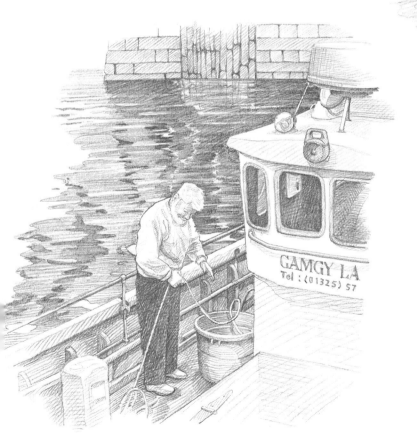

Getting the scale of figures exactly right within their surroundings is often the cause of artists' problems. Everyone, including me, tends to make people too big. Believe me, nothing looks less convincing than a ten-foot man standing in a six-foot boat.

Whether they're distant specks crewing a racing yacht or incidental bystanders on a jetty, it is essential to measure visually the height of figures by comparing them with any nearby feature, such as a ship's mast.

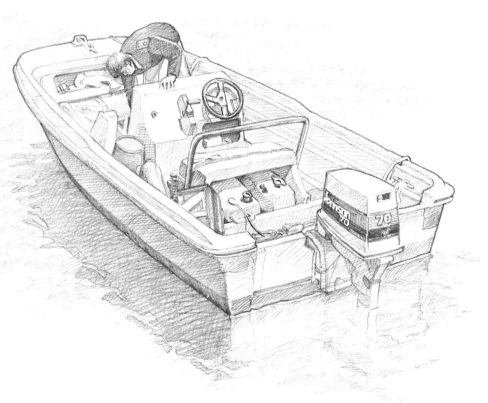

Conveying movement

One could regard investing a drawing with a sense of movement as something of a challenge. It is not always easy to follow a sequence of activity with the naked eye and capture the essence of it on paper.

Nonetheless, the combination of boats and water does create such opportunities,

particularly when billowing sails or a white-capped bow wave is in evidence.

Stormy seas can also offer the opportunity to convey a more dramatic kind of movement. This sketch on the right, of the outer harbour wall at Lynmouth, Devon, was begun on the beach but had to be completed in the studio because of the atrocious weather.

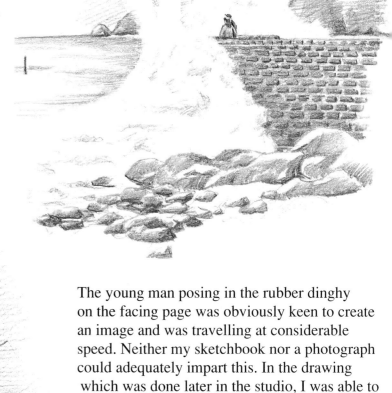

The young man posing in the rubber dinghy on the facing page was obviously keen to create an image and was travelling at considerable speed. Neither my sketchbook nor a photograph could adequately impart this. In the drawing which was done later in the studio, I was able to overemphasize the tilt of the boat and the wake of white water behind the outboard motor.

Yacht race at Porto Cervo, Sardinia.

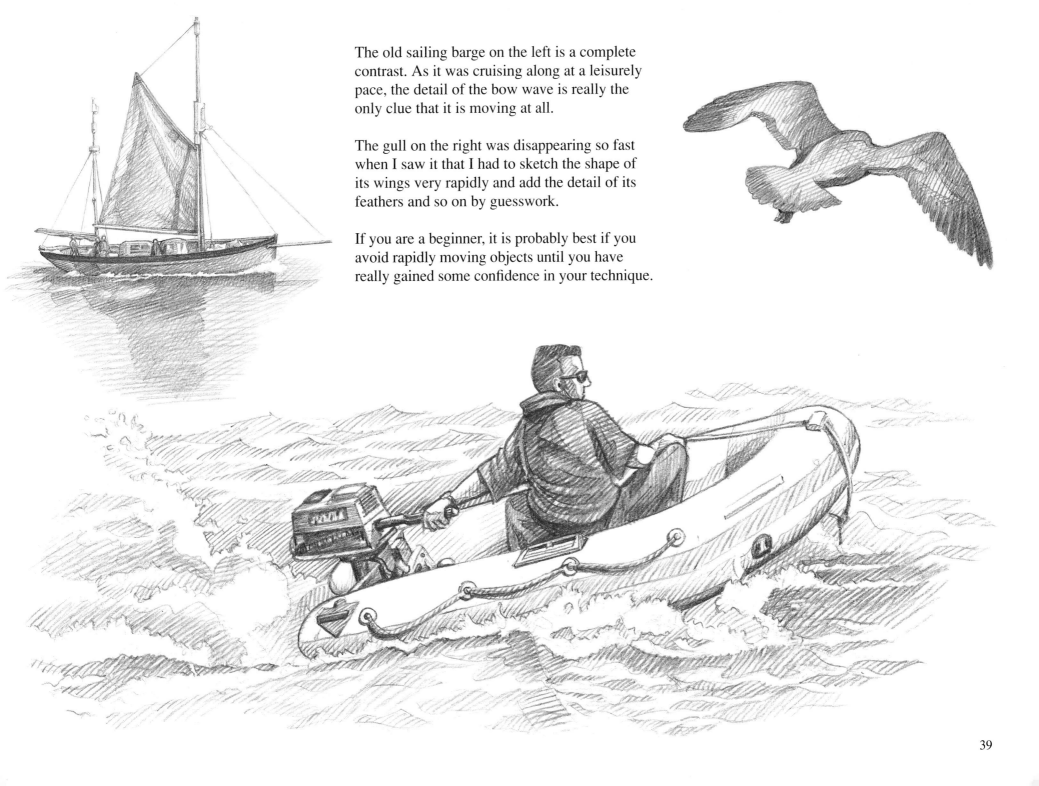

The old sailing barge on the left is a complete contrast. As it was cruising along at a leisurely pace, the detail of the bow wave is really the only clue that it is moving at all.

The gull on the right was disappearing so fast when I saw it that I had to sketch the shape of its wings very rapidly and add the detail of its feathers and so on by guesswork.

If you are a beginner, it is probably best if you avoid rapidly moving objects until you have really gained some confidence in your technique.

Mood and atmosphere

Conventionally it is drawings of a lower key or darker overall tone value which are imbued with a good deal more sentiment than those in a high key, or relatively light overall tone – such as the lad in the dinghy on page 39.

The drawing on the right shows the port of Anacona in Italy at dawn. I have deliberately tried to reduce the contrast and soften the edges of the ships and cranes in the foreground by using a 6B pencil with a well-rounded point – if that's not a contradiction in terms.

An added sense of drama in this sketch is created by the image of the sun bursting into an overcast sky from behind the city. The detail of the city itself was scarcely visible with the skyline forming a strong silhouette.

The use of a very soft pencil on watercolour paper creates a grainy appearance and reduces the differentiation between areas of tone even further.

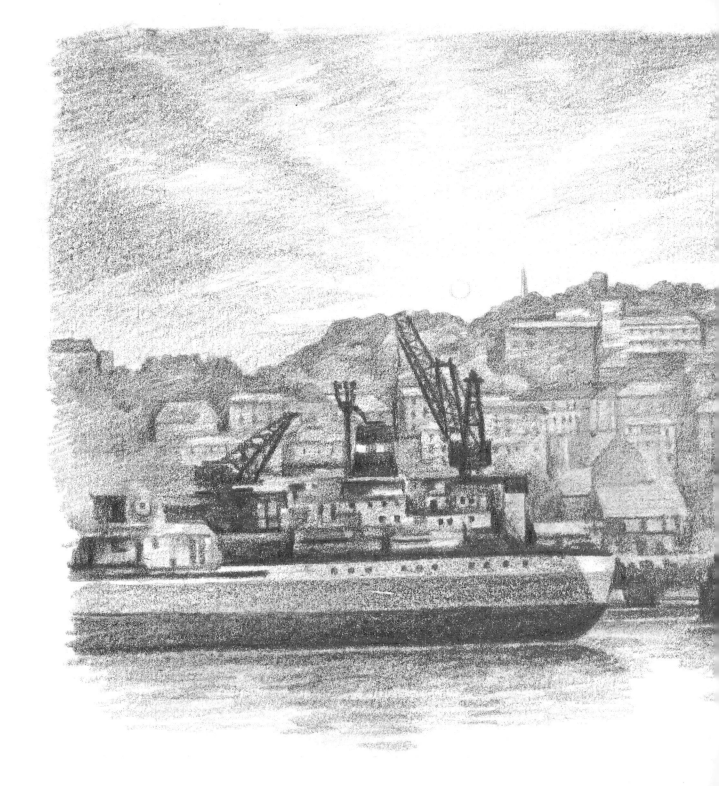

The sketch below is of Barmouth in Wales at low tide, at dusk on a warm summer evening.

To create mood, the key is again kept deliberately low, although smoother paper and a harder pencil have been used to render the boats on the sandbar in sharper relief. This artificial level of foreground contrast helps to make the bridge in the middle ground, and the hills in the background, recede.

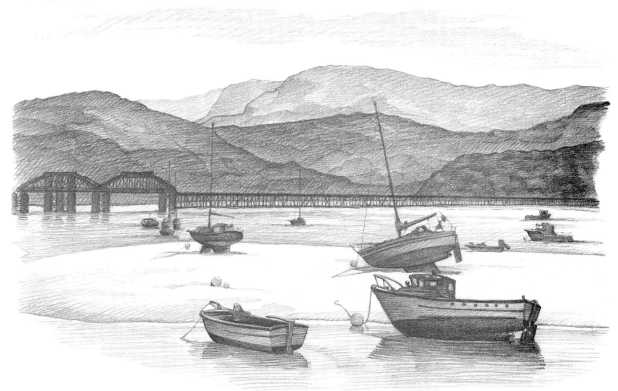

Alternative media

Even though this book is really all about sketching with pencils, there is a variety of other sketching implements which can be used to create many different effects. There are two main groups: pens and brushes; charcoals and pastels.

Pens and brushes

A lot of people use fibretips, biros or even fountain pens for jotting down quick impressions in a sketchbook.

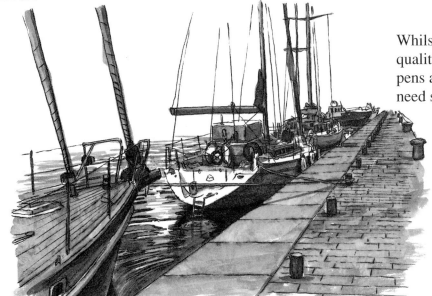

Whilst you do lose some of the subtle tonal qualities of a pencil drawing, ink or watercolour pens are convenient, clean and the results do not need spraying with fixative.

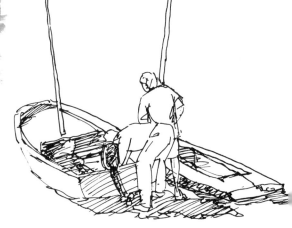

*Thin, fibretipped pen sketch
of Whitby harbour,
North Yorkshire.*

Rendering the line work in waterproof ink gives you the option of applying water-based wash on top of the original sketch. This technique is called 'line and wash'.

The drawing at the top of Whitby quayside at dusk was done *in situ* with a black ink Flo-pen. The wash was added later using a brush and a thin solution of black gouache.

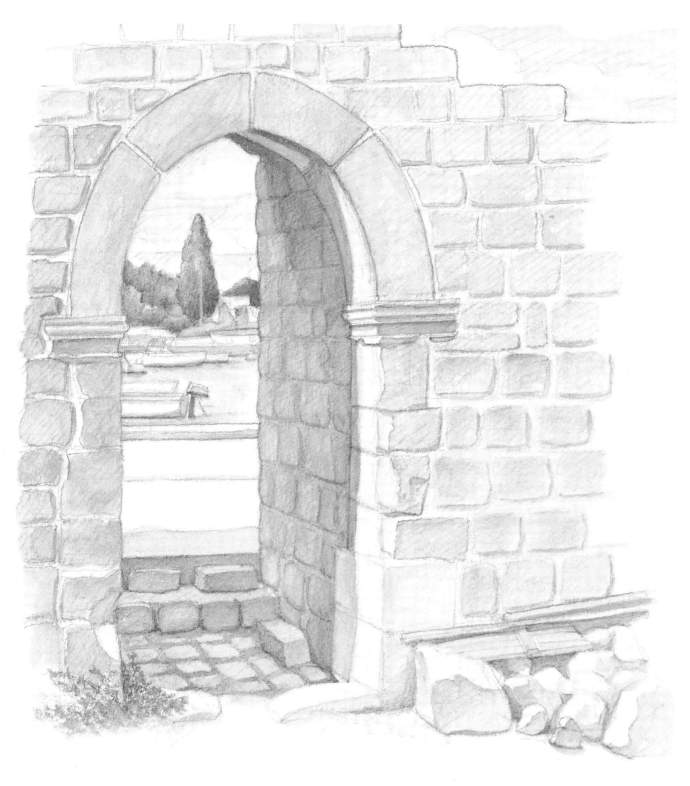

Having observed and interpreted the outlines and basic structure of the subject in pencil, one of the most popular media for adding tonal variation is watercolour.

The can be applied *in situ* if you have sufficient time or later using notes and/or photographic reference.

The outline sketch should, if possible, be rendered on paper which won't stretch or cockle when the paint is applied – for instance, Not or semi-rough watercolour paper.

One of the more recent inventions that has served to make the itinerant artist's life considerably easier and less messy is water-soluble pencils.

The painting on the left was originally drawn on Watman paper using Aquarelle water-soluble pencils and the tonal wash added at the same time by 'painting' with water only. The subject is an ancient, stone archway at Mali Ston in Croatia which was in the process of being renovated, having been damaged in 1997 by an earthquake.

Charcoal and pastels

Whilst being a fairly crude medium by comparison with pencils, charcoal has a strength and vibrancy which make it ideal for creating dramatic contrasts.

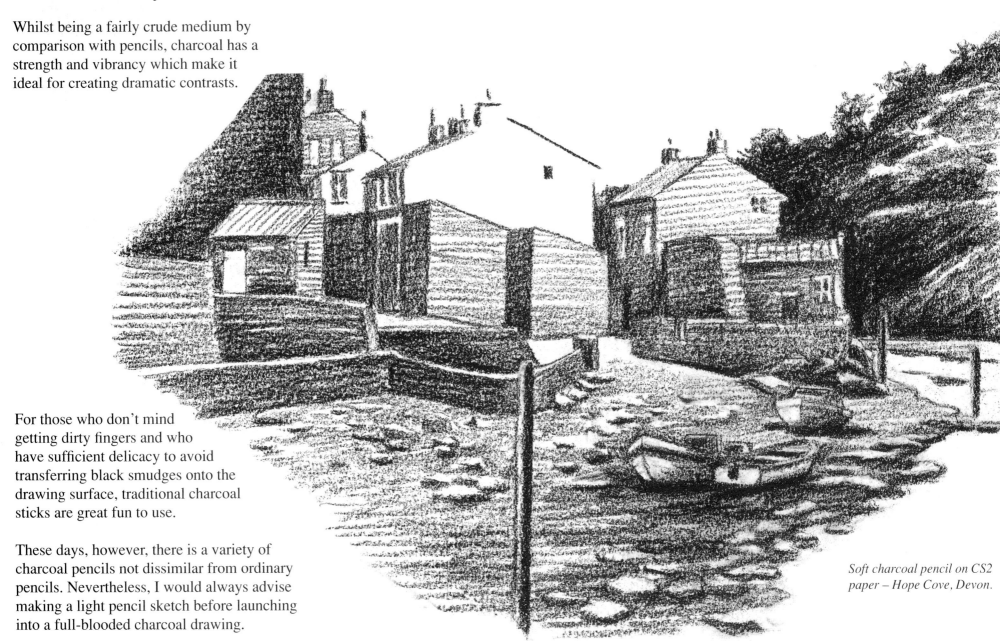

For those who don't mind getting dirty fingers and who have sufficient delicacy to avoid transferring black smudges onto the drawing surface, traditional charcoal sticks are great fun to use.

These days, however, there is a variety of charcoal pencils not dissimilar from ordinary pencils. Nevertheless, I would always advise making a light pencil sketch before launching into a full-blooded charcoal drawing.

Soft charcoal pencil on CS2 paper – Hope Cove, Devon.

Both oil pastels and pastel crayons give something of the flavour of working directly with paints but without the bother of having to clean brushes or wait for colours to dry.

It may be advisable, however, to equip yourself with a box of tissues and some thinners in a small jar, just to clean up dirty fingers and avoid smudges as you go along.

Again I would suggest doing an outline pencil sketch before applying either of these dense media. Oil pastels in particular are pretty unforgiving so try to work from light to dark, saving areas of deep shadow until the end.

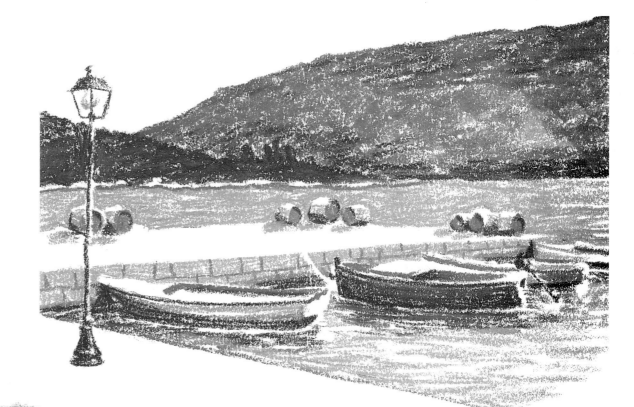

The sketch on the left, a yacht race at Salcombe, Devon, was produced with a black graphite pencil on CS2 paper. I could equally well have used pastel sticks to create a similar effect.

Above, the little fishing harbour at Mali Ston, Croatia, was 'painted' with pastel sticks, an instant medium which, if you're careful, can be worked over – especially if you fix the underneath layer first.

Finishing touches

Highlights and definition

In order to add that extra sparkle to your work it is sometimes a good idea to strengthen the outlines of foreground features, deepen shadows or add whiter highlights to the final result.

If you're working in graphite pencils it is quite straightforward to go over the dark areas with a softer, or blacker, pencil. Highlights can then be added either with a hard rubber sharpened to a point or a fine paintbrush and Process White, a virtually opaque, water-based medium similar to gouache.

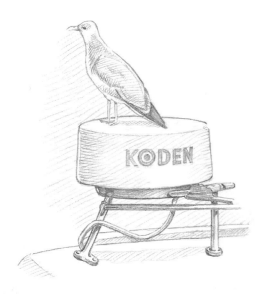

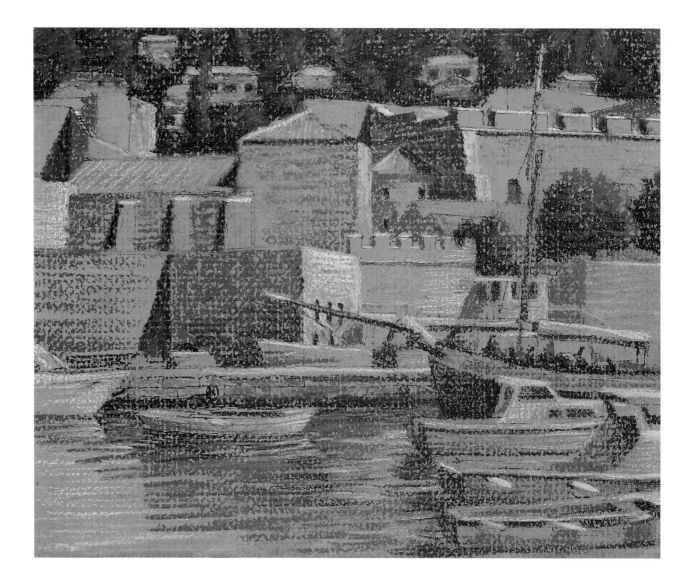

Pastels, as mentioned on the previous page, can be 'overpainted'. Oil pastels are easier to alter as the colour is more opaque. This drawing, of the Old City port at Dubrovnik, Croatia, was drawn in chalky pastels on grey Canson paper.

When it was complete, I fixed it, mainly to protect the dusty surface, and then, when it was dry, I revived the shadows and highlights with pure black and pure white pastel sticks.

Protecting your work

Charcoal, pastel and even pencil drawings do not take kindly to being handled roughly. If you can, always use a light coating of clear spray fixative or, if you're really stuck, try hair lacquer – which is a cheaper alternative.

Unfortunately, any protective spray has the disadvantage of darkening the image.

If you think there is a danger that your skilfully-crafted pencil gradations of tone might lose some of their subtlety, simply cover the work with a sheet of thin tissue paper and avoid touching the surface.

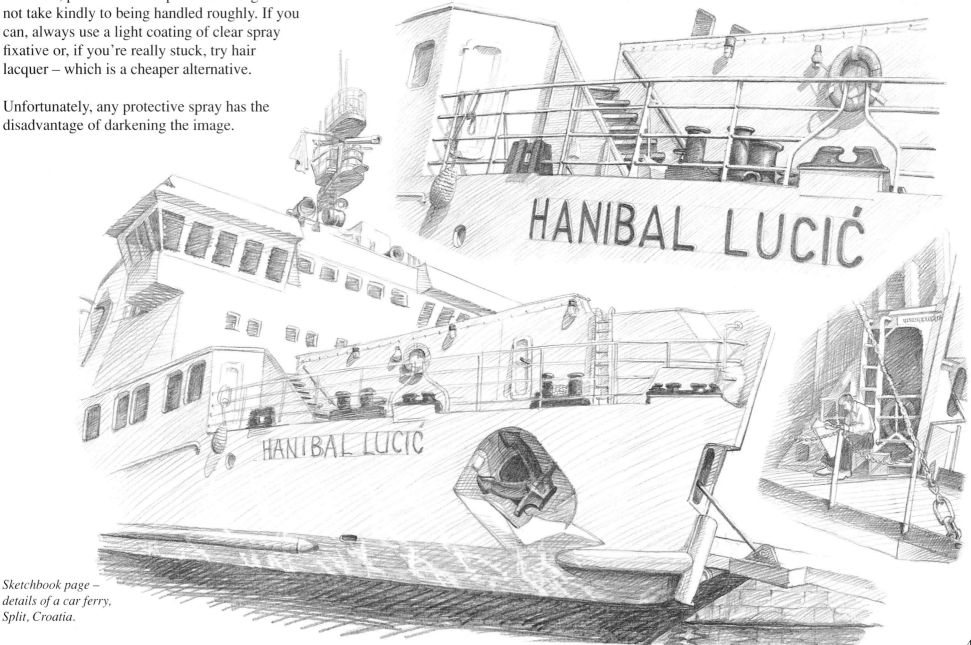

*Sketchbook page –
details of a car ferry,
Split, Croatia.*

Mounting and framing

I hope you will be proud enough of your efforts at sketching harbours and boats to want to display your work for all to see.

Monochromatic drawings are best shown in simple frames. I tend to go for plain, thin, grey beading or just steel clips and glass.

If you feel a mount is necessary, other than a plain white surround, choose muted or pastel colours as they tend to complement grey and black images rather better than bright reds, blues and greens.

I wish you well in your endeavours and I sincerely hope that you will enjoy, as I have, the unique pleasures that come from filling a sketchbook with your experiences.

Transporter bridge,
Newcastle-upon-Tyne,
Northumbria.